THE JACOB LAWRENCE SERIES

ON AMERICAN ARTISTS

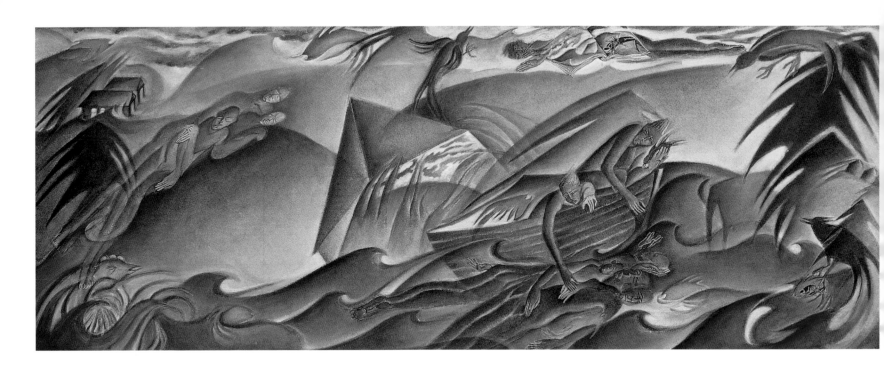

Fishers of Men (1995)

Egg tempera on paper

$11\frac{1}{2}'' \times 30''$

Collection of Mary Ingraham and Jim Brown

Photograph by Richard Nicol

STORM WATCH

THE ART OF
BARBARA EARL THOMAS

FOREWORD BY JACOB LAWRENCE

INTRODUCTION
BY VICKI HALPER

University of Washington Press *Seattle & London*

This book is published with the assistance of a grant from the Jacob Lawrence Endowment.

Copyright © 1998 by the University of Washington Press

Printed and bound in Singapore at CS Graphics

Designed by Audrey Meyer

Credit: Stanza in Dedication quoted from *Pablo Neruda: Residence on Earth and Other Poems.* Copyright © 1973 by Pablo Neruda and Donald D. Walsh. Reprinted by permission of New Directions Publishing Corporation.

Library of Congress Cataloging in Publication Data

Thomas, Barbara Earl.

 Storm watch : the art of Barbara Earl Thomas / foreword by Jacob Lawrence ; introduction by Vicki Halper. — 1st ed.

 p. cm. — (The Jacob Lawrence series on American artists)

 Includes bibliographical references.

 ISBN 0-295-97696-9 (cloth : alk. paper). — ISBN 0-295-97695-0 (paper : alk. paper)

 1. Thomas, Barbara Earl — Themes, motives. I. Title. II. Series.

ND237.T55175A4 1998

759.13 — dc21 97-51382

 CIP

ISBN 0-295-97696-9 (Cloth). ISBN 0-295-97695-0 (Paperbound)

The paper used in this publication meets the minimum requirements of American National Standard for Information Sciences—Permanence of Paper for Printed Library Materials, ANSI Z39.48-1984.

FIRST EDITION

03 02 01 00 99 5 4 3 2 1

In the depths of the deep sea,
in the night of the long lists,
like a horse your silent
silent name runs past.

—PABLO NERUDA, *from "Madrigal Written in Winter"*

Contents

Foreword

JACOB LAWRENCE

I WELCOME THE OPPORTUNITY TO CONTRIBUTE THIS STATEMENT ON Barbara Thomas and her art. Knowing Barbara for a number of years as both a colleague and as a friend has been for me a most rewarding experience. Viewing her many exhibitions over a period of years and sharing and agreeing with her ideas pertaining to the creative process in general, one can appreciate Barbara's overall commitment to her chosen field of art. Her technical skills as an artist in the handling of abstract elements of color, line, texture, shape, and value are inventive, dynamic, and exciting to view. In formalistic terms her works have scope and dimension. She continues to express with deep conviction and passion her perception of life. Her paintings are developed with insight and experience.

This publication is a well-deserved tribute to a fine artist who continues to contribute to the community in general, and to the art community in particular.

Storm Watch

INTRODUCTION

Storm Watch

VICKI HALPER

T HROUGHOUT BARBARA THOMAS'S YOUTH, HER MOTHER WOULD CALL the family to safety during rare Northwest thunderstorms, sheltering them in her collective embrace. Barbara and her younger sister, and sometimes her father, would lie together in the dark while a storm raged outside and her mother told stories of her life in the South. This image from the artist's childhood became the subject of two early drawings in which she merged her family and the Holy Family (figs. 1, 9). In them she tried to capture her sense of menace and foreboding during the storms, and her belief that a precarious security is found through embracing others. These themes are central to much of Thomas's more recent work.

The big old Seattle house where Thomas grew up was the locus of great activity as it often served as a way station for paid boarders and for friends and relatives who had fallen on hard times. People might stay an evening or a year, and their sudden, unexplained comings and goings led to a sense of impending loss that intensified the value of each attachment. This house and the relationships within it appear again and again in Thomas's work.

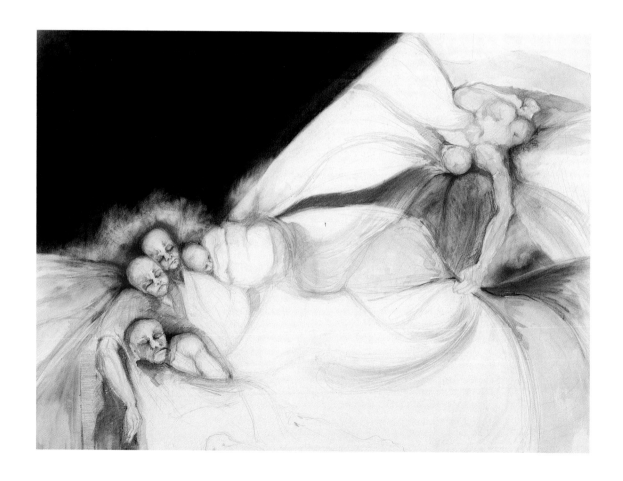

Barbara's birth father died of leukemia when she was two years old. Her second father, Grady C. Wright, married her mother Lula Mae three years later. She remembers him as a big man full of high emotions who was as quick tempered as he was ready to spin a tall tale about crocodiles from his Florida youth. He was the family's foundation and absolute protector. Barbara notes that her life has been marked by her father's strength, humor, and tale-telling, and by her mother's spirituality, superstitions, and conciliatory temperament.

Fishing was at the center of the most harmonious parts of their family life, bottom fishing in murky lakes, that is, not fly fishing in clear, shallow streams, which took expensive gear and wasn't done back South anyway. Almost every weekend her parents went out in a rowboat while Barbara waited on shore, sometimes sleeping in the car, sometimes anxiously checking for their boat, sometimes playing with other kids. She might have spent the night before out crawling in dark, damp places looking for earthworms amid the slugs. Family preparations were exacting, and there was sometimes joking and partying. In 1996 Thomas, speaking of herself in the third person, concluded a story about her family and fishing this way:

Fishing became a country, a place to go in the head and heart, an instrument for dreaming together. She knew this. And thus, she employed herself to listen, to watch, to catch their rhythm and match it by interjecting or underscoring just the right word and phrase to punctuate their play, to hold them in this country, as long as she could, where their energy seemed weightless, and the stresses of their daily lives evaporated. . . . It was a place where together they knew exactly how to prepare and what to plan for. And they were in charge of the mystery and all its possible fruit.[1]

The storms, the boats, the worms, the fish—all would become subjects for Thomas's later paintings. Like the family nestled in bed, they would shed the particulars of her life to become generalized and mythologized. The particulars would eventually appear in her writings.

At eight years old, Thomas and a friend took a long, unsanctioned walk due north from the Central District to Capitol Hill. As the houses got bigger and the lawns more groomed, Barbara thought: "My God, we've walked to Canada! This is Canada."[2] The University of Washing-

ton was a few blocks farther on, about two miles in all from her home. She crossed that border in the 1960s.

I entered the University quite by surprise in 1968. I was recruited by a young minister who also happened to be a part-time counselor for the University. He asked me why I wasn't in college and I had no answer, since going to the University never occurred to me as a thing I might do. So I went.[3]

Before 1968 Thomas's art consisted of gifts to family and friends. She'd had no idea that drawing and painting could be studied, or considered as a career. As an undergraduate she concentrated on printed textiles and painting and took a double major with French. She approached art and grammar with equal avidity, seeking those studies that provided structure: color theory for its elucidation of value and hue and, eventually, for its instructions in making infinite variations of grey without using black; French tenses for their clarification of thought, for their categorization of events that start and stop in the past, as distinct from those of indefinite duration, or those that are contingent or hypothetical. Grammar, Barbara said, was "a rock in the middle of that cloudy stuff."[4] Perhaps she felt like writer Alice Kaplan, who recorded in her 1993 autobiography (*French Lessons*) the life-saving qualities of school and language:

I had come from a house where the patterns had broken down. . . . Now I loved the loudspeaker and the study hall and the marble floor because they made me feel hard and controlled and patterned. . . . Learning French and learning to think, learning to desire, is all mixed up in my head, until I can't tell the difference. . . . French demands my obedience, gives me permission to try too hard, to squinch up my face to make the words sound right. French houses words like "existentialism" that connote abstract thinking, difficulties to which I can get the key. And body parts which I can claim. French got me away from my family and taught me how to talk. Made me an adult.[5]

Barbara's art professors remember a unique combination of intensity and humor, a hunger for information of all sorts, and an apparent self-possession that defied her insecurities about being in this strange environment. "She ate us alive!" Michael Spafford remarked about her demands to be taught. "You had to take her seriously," Jacob Lawrence said. "You could not be shallow or flippant. She raised the level of the whole class."[6] Thomas enlisted Norman Lundin to teach her

light and color theory, and Spafford and Lawrence to work with her on composition. She attacked painting as a language with rules that she was determined to learn by heart.

Brought into printmaking in the early seventies by her friend Christine Lamb, Barbara came to know a group of artists who later dominated the Seattle gallery scene—Carl Chew, Dennis Evans, Sherry Markovitz, and Norie Sato among them. Thomas was an undergraduate when they were graduates and was later than they to mature as an artist. This protraction of her development was largely due to circumstance. Through necessity, and sometimes also by choice, art was not always at the center of her life. Thomas was working throughout her college years to pay tuition and living expenses, and she worked full time from the moment of graduation. She also maintained close ties with her family and combined her energies with theirs to raise her niece. Her consequent slow maturation as a painter is valued now by Thomas when she reviews the time in her life before she first hit her artistic stride in the 1980s.

At the university it was Barbara's personality rather than her art that was focused, expansive, and promising. She painted one figure, often herself, then two, sometimes herself doubled. She painted landscapes without figures and made still lifes to practice color theory and to study light. She looked at reproductions of the work of Egon Schiele, Gustav Klimt, Emil Nolde, William Blake, Rembrandt, and Durer. In 1972 she received a $250 prize from Jacob Lawrence, jurist for the Links annual art exhibition, and made her first trip to the East Coast, alone, to see art. In the National Gallery she was determined to see every painting and, in her zeal, fainted from exhaustion and ecstasy. She was revived by museum guards, the only other blacks in sight. Separated from her first husband and studying French at the University of Grenoble in the summer of 1975, she sketched intimate body parts, housescapes, and more self-portraits—"Colette stuff," she comments. Her MFA project in 1977 was mostly batiks and paintings of many tangled bodies. Her theme was "Self Portraits and Personal Mythologies," but she states that this was about "skills, not therapy." Then she painted some women in a frenzied style with their hair zig-zagging across the paper and, at the time her mother was diagnosed with breast cancer, a winged figure bleeding from her nipples. These paintings were included in her first show at Greenwood Galleries in 1980, for which she received a negative review in *Artweek*.[7]

In 1979 Thomas began her first of a decade of jobs with the Seattle Arts Commission, this time as a coordinator for "Artists in the City." She painted cityscapes at night in a studio at the downtown YMCA where a fellow artist stopped by to see her work in 1980. He said her bright

colors were offensive and jarring and told her she should go back to her "root," which she understood to mean the quasi-African style and restricted palette of her batiks. This, on top of the bad review, precipitated a crisis for Thomas. She realized that she was unclear about her direction and that she had no retort for this visitor. She thought: "The next time someone says something to me about my work, I want to feel so strongly about what I'm doing that I won't care." In November 1980 she wrote in her journal, "The familiar and safe now seem strange and menacing. Change is my only escape. . . . I have grown too big for my skin like some snake. I struggle to leave it behind."

Thomas put all her old work away and sat down to catalog her strengths and weaknesses. She decided to give up what she considered her crutches and diversions—color and facial features among them. She closed the eyes of her figures. In 1981 she left Greenwood Galleries, writing to the owner: "I feel like I need a whole new approach; at this point I am not sure what that new approach will be, but I am working on it."[8] She asked herself, "What is my work about?" Of her strengths, she recalled, "I thought I knew I was a good storyteller." Of her weaknesses, she felt she had not developed a visual language, a vocabulary of forms and a syntax for her paintings. This is what she most admired in the work of her teachers Michael Spafford and Jacob Lawrence. She went in search of a style.

In her 1983 one-person exhibition at Seattle Pacific University, "For Women who Sleep with Crocodiles," Thomas emerged fluent in a new language marked by restricted color, by unclothed simplified figures, and by studied compositional devices such as the patterned echoing of shapes and lines. In her version of magic realism, spirits and humans inhabited the same territory. The stories Barbara began telling were poetic, not factual.

In the title image of the 1983 exhibition (plate 1), a sleeping figure is curled with two docile reptiles in a nest of leaves. The mounded body repeats the contour of the grasses; claws, fingers, and leaves have a similar spikiness; one crocodile's spine is like a leaf's rib and a forehead's midline. All forms in the painting are outlined in white, the result of a wax resist technique like that used in batik. The figure, Barbara says, is pale to differentiate her from the dark environment, not to indicate her race. She is in the wild, but not alien. She has accepted cohabitation with beasts. I think of some places Barbara has slept—with her family during storms, in cars while her father visited friends, beside lakes while her parents fished. She has accommodated to whatever dangers

might be present. In the painting, she tames the danger exemplified by the crocodiles that inhabited her father's Florida tales.

In "Communion," from the same series (plate 2), the nest seems barren and cold. The face is squinched in concentration as it eats a nameless red thing, perhaps a tiny reptile. I think less of the Christian Eucharist suggested by the title than of two phrases: "you just have to swallow it," connoting the repression of ills that cannot be changed, and "it is hard to swallow," connoting the difficulty of such repression. In this initiation rite, the figure prepares to swallow something unknown and unpalatable; the artist indicates here that quietly resting beside reptiles is not always possible. By swallowing them we acknowledge and digest their presence.

All the paintings in Thomas's 1983 exhibition were made using tempera paint on large sheets of mulberry paper. While the scale of her work has changed over the years, the unusual medium has not. Severe asthma prevented Thomas from working in oils, so she chose tempera—pigment in a water-and-oil emulsion such as egg yolk—after trying out all forms of water-soluble paints. Tempera is an exacting medium, difficult to alter. It generally requires methodical planning and meticulous brushwork and is rarely chosen by impulsive painters when other options are available. The Northwest region has been rich in tempera painters, however, starting with artist Mark Tobey. Jacob Lawrence used tempera at the time of his debut during the Harlem Renaissance, although he was later to employ gouache (opaque watercolor). In 1979 Thomas's schoolmate Sherry Markovitz used both tempera and gouache in a series of large paintings on rice paper mounted on linen. She relieved Thomas's fears of this touchy medium by her casual approach. Finally, tempera was the medium of the early Italian Renaissance, and its use by Giotto, an artist beloved by Thomas, sealed her attachment to it.

Between 1979 and 1989 Thomas worked for the Seattle Arts Commission, first as program coordinator for literary and traditional visual arts, then as project manager for the 1% for Art program. Diane Shamish, her supervisor and colleague starting in 1985, noted that control of the organization had moved from artists to career bureaucrats by the late 1980s, but that Thomas would always be identified with the former. Shamish was emphatic: "There is NO ONE like

Barbara, especially in city government. If staff was expected to stay at their desks, Barbara might dance on hers." She combined constancy and focus with passion, integrity, and spirit. She was in the bureaucracy but not consumed by it, and, for a brief time in 1984, she painted her disdain for it.

The series "Meetings, Men, and Madness" comprised Thomas's first one-person exhibition at Francine Seders Gallery, Seattle, in 1984. She showed paintings about the subtext of meetings: who co-opts whom; who steps on whom; who is nameless. In "The Trinity" (1984, plate 3), three suited men perform a tight, obsequious dance under a civic arch. As they fawn, wheedle, and insinuate, flattened shadow-figures under their feet raise their arms to shield their heads. Other faceless figures crouch in the spandrels and pediment of the arch: the workers who support the institution but are outside the corridors of power. This is as close as Thomas comes to social realism, the pointed study of the specifics of community life and particularly of those social ills one wishes to expose. The topic, like the bureaucracy itself, she found too confining. It remained tangentially in her work for only about a year, in paintings such as "Passing Secrets" (1985, plate 6).

While retaining the compositional tightness and stylized posing of her "Meetings" series, Thomas returned to the unclothed figure and to family memories, abandoning the subject of power for the study of mystery. In "Reunions, My Mother, and Dreams of Fish" (1984, plate 4), the mother shields the nestling child. Their figures are constructed of straight lines and arcs; their limbs fold in sharp joints, like origami constructions. The pair is framed by the pediment of an overhead roof, its bracing horizontal aligned with the mother's outstretched arm. Fish seem to flow from her hand and merge with the leaves that are part of the sleeper's dreamscape. For Thomas's mother, a dream of fish foretold a birth. The painting associates lush fecundity with loving protectiveness. It places both under domestic shelter, where it is safe to have mysterious dreams.

The cacophony of a house centered on a nuclear family but filled with boarders is recalled in Thomas's painting "In My Father's House There Are Many Roomers" (1985/86, plate 7). An idealized family, like that in "Horizon Sleepers" (fig. 9, see p. 45), is surrounded by a miniature corps de ballet of guests, barely contained by the walls. The mother cradles one roomer; others use the father's body and shoulders for support. They circle the house the way Thomas's figures of the mid-1990s will frame the paper.

20

Outside the house a phantom steals away. Such shadow figures, colorless and transparent, first appeared in Thomas's painting "When Two Dance" (1983). She has used them since to manifest hidden or unknown forces. In "Luna Rescue at Daybreak" (1985, plate 5), for example, the shadow figure lurks beside a palm, ready to thwart the abduction of the moon. The shadow figure cannot be cradled or controlled, and the fears it signifies often as not come true. For Thomas, such figures are the force that can tip the balance from order to chaos within the house, like lightning waiting to strike during a storm.

Two paintings from 1987 illustrate Thomas's working method. "Man Cleans Fish" (plate 9) is the study for "A Man Cleaning His Fish" (plate 10), and, like most of the artist's initial compositions, it is looser in style and less complex in iconography and composition. Yet the fisherman seems more empathetic in the earlier work and the design less contrived. The painting is imbued with the particular memory of Barbara's father, precisely gutting his catch in his weekly post-fishing ritual. There is a sense of shared mortality.

In the later painting, the man is akin to a disinterested surgeon. While he is more articulated than in the study and his catch in the pail is more detailed, the artist's intent is away from the natural and toward the spiritual. The man is encircled by wondrous things. A fish floats off the table where it formerly rested; another hangs outside the window like a specter. A trio of spirits inhabits the floor; their demeanor is ambiguous. In one, I see the ennui of children; in another, anxiety about the task; in the third, identification with the fish. All this supernatural activity is ignored by the man, who concentrates on his task. His architectonic knife has made the slit, and his hands now enter the belly to finish the task.

At this time Thomas's work compares to the paintings of Jacob Lawrence in its flattened forms, shorthand descriptions of human figures and facial features, emphasized and articulated hands, restricted (although different) palettes, and geometrically structured compositions. In Lawrence's "Builders No. 1" (1972, fig. 2) and Thomas's "Man Cleans Fish," a man intent on his task sits before a picture window. Lawrence's man is clothed and uses a chisel to shape and construct; Thomas's man is nude and uses his hands to gut. Mount Rainier is outside one window; the ghost of a fish is outside the other.

Lawrence's work, unlike Thomas's, is filled with details of historical situations and daily lives—stories of liberation and visions of communities working, reading, and praying together. His figures are dark- and light-skinned because they are Negroes and Whites; the tools that his

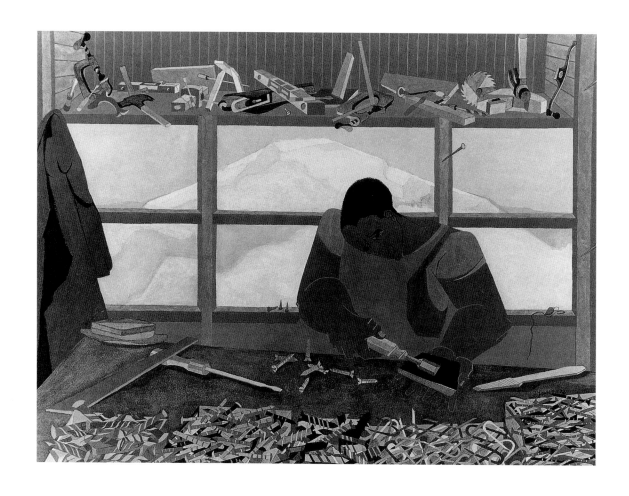

carpenter uses are nameable and exact; the place outside the window can be found on a map. There are exceptions to this generalization, and these are closer to Thomas's aim in their suggestion of dark internal forces or universalized anguish: some paintings of the 1950s such as "Masks" (1954), and later, "Ordeal of Alice" (1963), and the Hiroshima series (1983). But even Lawrence's darker visions are couched in the evidence of daily life, and his overriding tendency has been to celebrate the history of a people, to paint hopes, not fears.

Thomas in the 1980s paints about anxieties caused by a world full of portents. When she recalls an episode from her childhood, like worm-hunting in "Night Crawlers and Earth Worms" (1987, plate 11), the pails and flashlights are absent, but a phantom companion appears. The crawling figures are uneasy primordial earthlings, slithering through grass. They are closer to the mud than are the golden worms they seek. In "The Boat" (1988, plate 12), a couple is adrift, neither fishing nor rowing; no poles, nets, oars; no anchor. Their embrace is apprehensive, as it should be with a shadow figure threatening to push them overboard and a homunculus being swept away. This painting about the human condition by someone who fears the worst was completed eight months before Barbara's parents, on a beautiful day in September 1988, drowned while fishing. "Found floating," she read in the autopsy report.

I felt the world split, and I saw my life divide itself squarely in half there on that moment. It was clear that everything from then on would be defined in my life by whether it happened before or after this moment," Thomas wrote three years later.[9] She arranged the funeral, handled the estate, and cleaned house maniacally. Her niece moved in with her and Rick Simonson, Barbara's companion of three years whom she would marry in 1990. It had been understood in the family that Barbara and Rick would parent her niece during high school, but the death of her parents now also thrust Thomas into the weighty position of head of family.

In the funeral program, Barbara quoted James Baldwin:

I think I know how many times one has to start again, and how often one feels that one cannot start again. And yet, on the pain of death, one can never remain where one is. The light. The light. One will perish without the light.

It is a mighty heritage, it is the human heritage, and it is all there is to trust. And I learned this through descending, as it were, into the eyes of my father and mother. I wondered, when I was little, how they bore it—for I knew that they had much to bear; but they knew it, and the unimaginable rigors of their journey helped them prepare for mine. This is why one must say Yes to life and embrace it wherever it is found—and it is found in terrible places; nevertheless, there it is; and the child can learn that most difficult of words, AMEN.[10]

Thomas had begun "The Storm Watch" (1988, plate 13) before she learned that her parents had drowned. She originally considered the painting as an exercise in abstracting the more literal parts of her previous work—couples, fish, water, houses. The house and the pair in the foreground had been painted, the waves were gentle, and the sky was unconsidered but light. While she was painting, she remembers listening to Joe Ligon of the Mighty Clouds of Joy and Aretha Franklin singing the gospel "I've Been in the Storm Too Long."

She returned to "The Storm Watch" some months after her parents' deaths. She abstracted the waves into buzzsaw blades, placed a fish between the couple, turned the sky into a tempest, and added more figures beneath the house, which now loomed like a tombstone. The original couple, who might once have nestled snug in bed during a storm, are at sea in the middle of the maelstrom. They embrace weightlessly, or perhaps one lightly carries the other. They ride the waves with a fish whose tail is like another clasping hand. Behind them a small shadow-couple also embraces, but like mourners. In a miniature landscape of its own, tucked under a roof of its own, a tiny boat carries a solitary figure who is both sheltered and adrift.

The painting is intensely stylized—rows of waves like sharp paper cutouts, images echoing and reversing one another. For Thomas, dread has become fact. In her painting, turbulence is made bearable by pattern.

Many of the changes catalyzed in Thomas's painting by her parents' deaths have their origin in "The Storm Watch." By shrinking the figures within the landscape, detaching them from solid ground, and increasing the dominance of sea and sky, Thomas creates the sense of

natural or cosmic catastrophe in which humans are but a part. She also begins to stretch the picture plane into the exaggerated horizontal of the 1990s.

These changes highlight Thomas's affinity with Guy Anderson (b. 1907), a Northwest School artist in the circle of Morris Graves and Mark Tobey during the 1930s and 1940s who shares in their identification as "mystic painters."[11] Anderson and Thomas by the 1980s were both showing at Francine Seders Gallery, Seattle (Anderson since 1968 and Thomas since 1984), and Thomas is unhesitating in her admiration of his work. Thomas, like Anderson and other regional artists, uses a muted palette and paints on paper. She has come to share with Anderson in particular the highly patterned surface and elongated format that he used in his seascapes of 1958–59 (fig. 3), and the placement of universalized figures, Everyman, in vast, ambiguous space.

Anderson is particularly noted for figures floating above a cosmic disk or a tempestuous sea (fig. 4). They may be stretched like sleepers, with a hand dangling towards earth, or balled like seed pods. Sometimes the figures seem essential parts of a universe that is constantly rebirthing, sometimes mere cosmic flotsam and jetsam. During the war years of the later twentieth century (World War II, Vietnam, Beirut), Anderson's figures rise into the sky as a result of bombings, although historical references as such are rarely evident in his paintings or their titles. This is a trait shared by Thomas, whose sensitivity to actual horrors in the contemporary world is acute, but whose later paintings are apocalyptic rather than topical. In her work, however, the horrors are unrelieved by the disinterested cosmic consciousness that quiets Anderson's paintings.

In Thomas's "Broken Landscape" (1990, plate 14), from "The Fallen House" series, catastrophe has invaded everyday life. The table is set but is in disarray. The empty chairs tilt, the waves lap at the edges, and the plates have each become a miniature canvas for other scenes, including a figure curled like the one in "Communion" (plate 2) and a chicken, used by Thomas in many paintings as a symbol of what is mysterious, intuitive, and untameable. ("A chicken is not a pet," she'll note, remembering the terror she felt as a child upon awakening alone on one fishing trip to find herself surrounded by pecking hens.) Inside the tilting house a couple sits at a table, ignoring the storm; outside, seen through the window, a figure throws up its hands in the classic pose of despair. Far in the background, two shadow figures hold on to each other. In Thomas's earlier paintings, the trees had been palms, evoking the landscape of her father's stories and the vegetation Thomas had loved from her many trips to the Caribbean before 1988

FIG. 3 / GUY ANDERSON

Deception Pass Through Indian Country (1959)

Oil on board

11″ × 30½″

Seattle Art Museum, gift of Sidney and Anne Gerber

Photo: Chris Eden

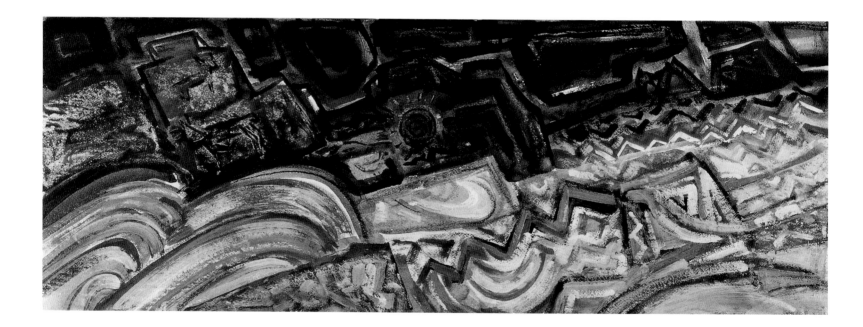

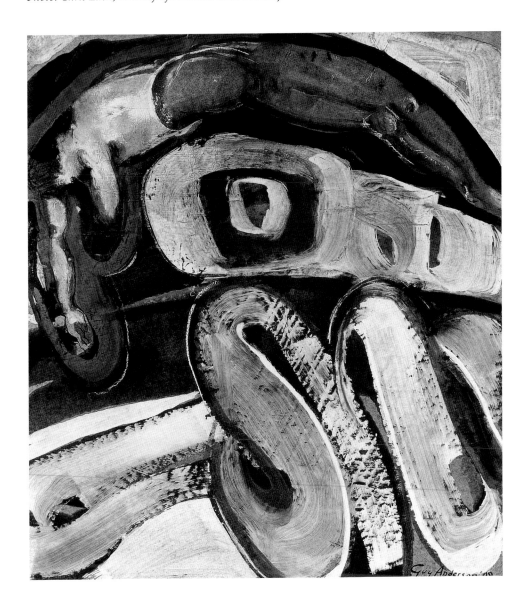

in search of sun and warm water. The trees are now pines—a reminder that the water of the deluge is cold.

In 1991 the Seattle Art Museum asked Thomas and five other artists to create works for "1492/ 1992," an exhibition commemorating the 500th anniversary of Columbus's landing in America. The curators (Patterson Sims, Rod Slemmons, and myself) chose artists who could address the complex, sometimes contradictory, political and emotional issues surrounding this anniversary—discovery, conquest, awe, plunder, enslavement, and hope. Characteristically, Thomas tackled the resonance of the event while shunning historical details. To accompany her sculptural installation, she wrote:

In 1992 we celebrate discovery, while we grieve for the loss of the endless frontier which sparked our imagination; in 1992 we celebrate abundance, technology, and the wonders of science, while we long for the oblivion of blessed innocence; in 1992 we celebrate the conquering of nature, while we grieve for its loss, the embodiment of hope and faith held within its once vast mystery. . . . We come to the table after 500 years to account and to honor the purpose of memory. In remembering, we remake, put back together in the present something that has been rended asunder.[12]

In "What Is Found, What Is Lost, What Is Remembered," Thomas created a sculptural memorial, a place for recollection, in front of a backlit silhouette of a house, ten feet high and painted black (fig. 5). This house—part shelter, part tabernacle, part tombstone—was fronted by a field of stones dotted with markers or spirit poles: turned wood balustrades on which she mounted flat cardboard cutouts of houses, crosses, and crows, and house-like boxes made of papier-mâché. The cutouts and boxes served as surfaces for paintings that expressed a sense of deep crisis in community (houses), belief (crosses), and environmental stewardship (crows)— all endangered, engulfed by fire and waves. The looming silhouette enclosed it all, intimating that we are all under the same large roof.

Not a graveyard, Barbara said to me in 1992, but a garden. What is important enough to

FIG. 5 / BARBARA THOMAS

What Is Found, What Is Lost, What Is Remembered (1992)

Egg tempera on paper, wood, rocks, metal, and found objects

120″ × 72″ × 126″ overall

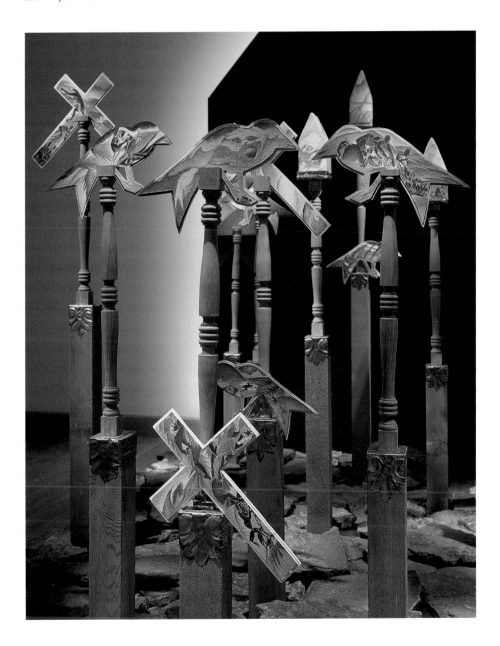

remember is important enough to live for. The central fear is loss of connectedness; the central hope is holding on to community, faith, and nature.

Thomas's installation traveled to the Whatcom Museum in Bellingham, Washington, in 1994, accompanied by a group of thematically related paintings made between 1988 and 1994. She called the exhibition "The Fallen House," a title that refers to her toppled structures while conjuring up biblical references to The Fall—the end of innocence and grace following Adam and Eve's transgressions in and expulsion from the Garden of Eden. Thomas's world is clearly post-Edenic, despite her hope that her installation be seen as a garden. In the paintings, the lushness, order, and harmony of Eden is gone, along with human purity, simplicity, and carefreeness. Moreover, when the flood comes, as it does in the Book of Genesis, the artist provides no Noah and no Ark. "Can we leave and get it right the next time?" Barbara asked at the time. "The answer is no."

A shift in the artist's vision is occurring. The source of the menace and foreboding in her work is no longer an internalized sense of dread; she has now identified human failings in the eye of the storm.

Thomas called her next group of works "The Book of Telling," underscoring her devotion to reading, storytelling, and the bound format in which memory has been encoded since the advent of writing. Books began appearing in her work after 1990, although, like the dinner plates in "Broken Landscape" (plate 14), their open pages held miniature paintings within paintings rather than words. Books were powerful presences and precious treasures in her life long before her marriage to Rick Simonson, buyer for the Elliott Bay Book Company in Seattle and the driving force behind its renowned series of in-store readings by authors. Thomas met Simonson in 1983 after she initiated a literary arts program with the Seattle Arts Commission. When Thomas left the Commission in 1989, she worked part-time coordinating the annual Bumbershoot arts festival and part-time as advertising and promotions coordinator for the bookstore. She still holds the latter position. Literature, writers, and her own writing are as central to her life as art, and usually occupy more of her waking hours.

In 1993 Thomas became fascinated by books that combine illustration and text, particularly medieval and Renaissance illuminated manuscripts, and she began to consider creating her own Book of Days with meditative writings and border illustrations. The paintings in "The Book of Telling" are in part a preparation for this endeavor. She continued to develop the elongated format, stretched her figures to parallel the exaggerated horizontal, and compressed and overlaid her images to create a density worthy of the meditative texts she was studying. However, although twelfth- to fifteenth-century illuminated manuscripts with their painstaking brushwork were her model, Thomas's work of the 1990s seems most closely akin to that of the British artist William Blake (1757–1827).

Blake was a poet, printmaker, and painter who is revered for his integration of drawing and words and his intensely personal, prophetic vision. He illustrated his own poems and metaphysical texts as well as great works of Western literature such as the Book of Job, Milton's *Paradise Lost*, and Dante's *Divine Comedy*. "Minos," one of his watercolors for the *Inferno* (fig. 6), shows stormy seas with waves that peak like flames, as in Thomas's "Echo Tides" (1991, plate 15); elongated figures that are both skyborne and merging with the land, as in "Place Set, Lost Place" (1995, plate 19); and a swirl of figures around the frame, as in many works in the series "The Book of Telling." When Thomas begins her Book of Days, the center of her paintings may be replaced by text and the marginal images may become as integrated with words as they are in Blake's illustrated texts.

The setting for the title painting, "The Book of Telling" (1995, plate 17) is toppled houses, scalloped clouds, roiled surf, and tumbled trees. Figures, which had become less prominent in "The Fallen House" series, repopulate the landscapes, as will flocks of birds and monkeys in other paintings from this period. Here a person nestles within a house that rests within the breast of a large crow. I imagine the bird cawing "Hark! Hark!" like some ancient prophet. Three boneless shades rise from the surf like vapor. On the right, a figure with hand over eyes is not heeding. Another is intent on a book that I imagine catalogues all the images of the Apocalypse. Thomas wrote for the gallery:

I take nothing for granted. Air, water, trees, light, the voices of children all seem tenuous these days. . . . At the end of certain days, at the end, soon, of this century, we are looking for reason and reasons,

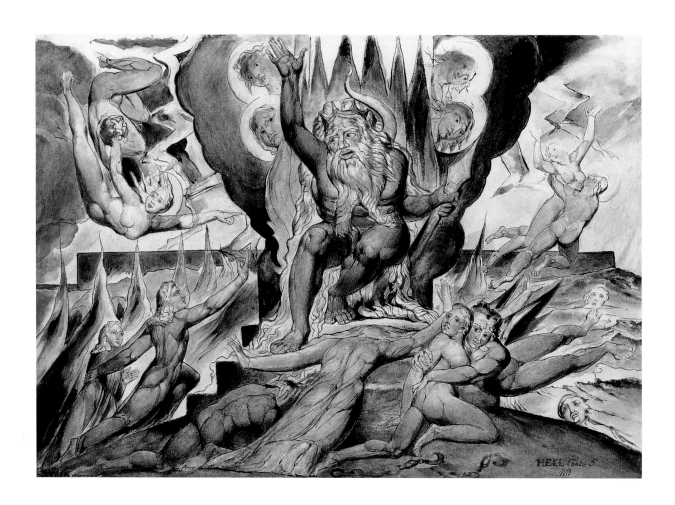

causes and effects: ways to justify our fallen state that do not negatively implicate us. . . . We cast a blind eye: it's not my country, my city, my job, my neighborhood, my family. It's not my child. But no witness is innocent.[13]

In a slightly later painting, "Point Blank, Blank Book" (1995, plate 18), birds, monkeys, and figures are arranged in a border surrounding a landscape that is less turbulent, as in the wake of a receding flood. The bodies are piles of the dead, jointless and submerged, abstracted from the carnages of our city streets, of Rwanda, and of Sarajevo, much on Thomas's mind at the time. She uses the terms "cultural bloodletting" and "slaughter of the innocents." She preserves the bodies here like pressed leaves. Two monkeys, symbolic of an unself-conscious state, see no evil. They occupy the central, tilted house that is not an Ark. One holds a book with empty pages that encode no memories. In the painting's left margin, a figure caresses a bird and reaches for another—perhaps a hope:

And finally we are all falling. Connected by fear we grab for one another. It's our only hope and it's a good one. In an instant we are forced by gravity to abandon logic for our rusted faith to determine which hand will hasten or break our fall. . . . Like a dying man we are praying all the time to live in a way that matters and for a future in which we will not exist.[14]

"Place Set, Lost Place" (1995, plate 19) was sold and returned twice, with apologies—"Sorry, we don't think we can live with it." It is not easy to share one's home with a voice crying doom, for at this time Thomas was clearly painting in a prophetic mode. The nameless anxieties and mysteries of her earlier work had been replaced with a sure and dreadful vision of a fallen world. The painting's midline falls on the rump of a stacked body; its action is compressed to the left. A carrion-eating crow halts the visual flow into the emptier right side of the painting, where an airborne figure is becalmed and the hillside beneath is bare. The title tells us we have lost our place at the table, perhaps the table the Lord has set for his flock in the Twenty-third Psalm:

> *Thou preparest a table before me. . . . My cup overflows.*
> *Surely goodness and mercy shall follow me all the days of my life;*
> *And I shall dwell in the house of the Lord for ever.*

The empty hillside recalls the Twenty-fourth Psalm:

Who shall ascend the hill of the Lord? And who shall stand in His holy place?
He who has clean hands and a pure heart.

In our ungodliness, with our spiritual and ethical failings, we have overturned the table and lost our shelter. In our impurity, we are not worthy to occupy the sacred space of this earth. Surely Thomas, eyeing the storm, hopes that we might repent and change, that through righteousness—fundamental honesty, responsibility, and loving kindness—we might reset the table, square the house, and calm the gale. Until then, she will continue to bear witness to the torrent.

NOTES

1. Barbara Thomas, "Some Fly," *The Raven Chronicles*, Fall 1996.

2. Jonathan Raban, "America's Most Private City," *Travel Holiday*, November 1991, 105.

3. Barbara Thomas files, 1979 application for study abroad.

4. John Callarman, "Artist Wants to 'Make Space Better'," *Mt. Vernon Register News*, February 17, 1990, 1.

5. Alice Kaplan, *French Lessons: A Memoir* (Chicago: University of Chicago Press, 1993), 53, 140–41.

6. Unless otherwise dated, all unreferenced quotations are from interviews with the author conducted in April 1997.

7. "Unfortunately, the more painterly portraits fall prey to the obsessive and laborious handling of paint that haunts this show." Ron Glowen, "Indecisive Paintings," *Artweek*, May 17, 1980.

8. Barbara Thomas files, letter to Janet Laurel, October 13, 1981.

9. Barbara Thomas, "The Golden Light of Autumn," unpublished manuscript, September 1990.

10. James Baldwin, "Nothing Personal," in his *The Price of the Ticket: Collected Non-Fiction, 1948–1985* (New York: St. Martin's/Marek, 1985).

11. "Mystic Painters of the Northwest," *Life*, September 28, 1953, 84–89.

12. Barbara Thomas, in Seattle Art Museum, *Documents Northwest: The PONCHO Series; 1492/1992*, vol. 10, no. 2, 1992.

13. Barbara Thomas, *The Book of Telling: A Prayer for the Turn of the Century*, brochure (Seattle: Francine Seders Gallery, 1995).

14. Ibid.

Passing Secrets

BARBARA EARL THOMAS

IN MY COUNTRY, WINTER IS THE COLOR OF SLATE, A GRAY PLACE ON the landscape where light yields no shadows. It's a season that lives on the land and in my imagination, shaped by the lives of my southern family. These were lives wrought from the mud and dust of their country, which they carried to the Northwest from an old South that I will know only through the visions and customs they chose to give me. It's from this dual berth that I see the world.

A History of Arrival

My grandparents moved to Seattle in the early 1940s. They came, like many foreigners who settled here, from another country—theirs being the lands of the southern United States which are Arkansas, Louisiana, Texas, and Florida. They came, drawn by a wartime economy that was

breathing life into Seattle's shipyards and steel mills. Leaving their birthplace and all that they knew behind, they joined the ranks of the Negroes who journeyed to the Northwest by working their way across the South, pulled by the prospect of good jobs and a better life. They traveled like a slow-moving human chain, stopping only briefly to stay with relatives or friends along the way. At each stop they worked the fields in an effort to earn the family's trainfare north. These migrants cast their lot in human stones, throwing out one and then another, which required, as often as not, that parents leave children or husbands leave wives behind for a time. On their journey, one or two of them, in cell-like clusters, ventured on ahead to find work and a place to live. My grandfather, like many, was lucky enough to get a foothold, which enabled him to send for those like my mother and aunt who had been left behind.

In the displacement of their arrival, my family were immigrants like any others. And they would find little in this place to remind them of their southern landscape or the routines of their former lives. In this new land, the sum total of their families would no longer encircle them, nor would the white-hot sun of summers they had known burn down on them. My grandparents were sharecropping people who had worked the land owned by others, scratching out a living from dusty fields. Working away under the sun as they had, their hopes were modest. What little they hoped for—a job, a house, and some small future—now loomed immense, given how far they'd come. Their memory of sun would soon be dimmed by foggy mornings rolling in off the Sound and cooled by the hundred different kinds of rain they were to find here. To ease their passage over the great distance, much had been discarded, but they would hold onto their passion for fishing. This they carried with them from the bayous and fishing holes of the South as one of their ritual belongings, rooted deeply in their way of life, to be transplanted in among the pines and conifers of their new home.

By the late 1940s and on through the early 1950s there would be a second influx, bringing with it tribes of young men. Many of them, also from the South, would be stationed at one of the area's large army bases: Fort Lewis or Fort Lawton. Constituting another kind of migration, these young men and boys, waylaid here as they were by yet another war, were destined to join in with those families, especially with the daughters, whose arrival had just preceded theirs. It was the young people of this second wave who would become the parents of my generation. And this was how my grandparents and parents came to be planted here, blown in like so many seeds from all parts, mixing their regional southern accents and customs to create a kind of hybrid. And while

FIG. 7 / BARBARA THOMAS

Saving Grace (1995)

Egg tempera on paper

10″ × 13″

Collection of WRQ, Inc., Seattle

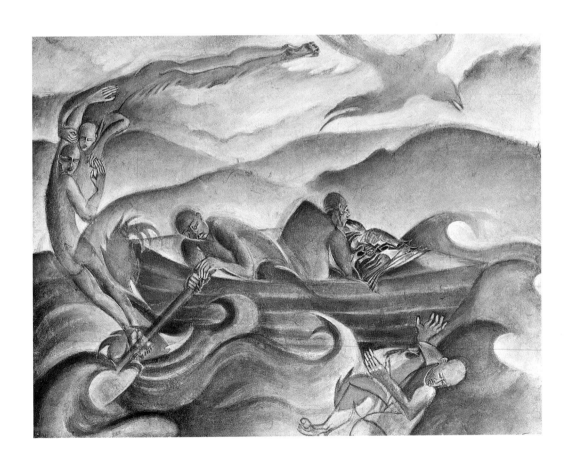

they were all, strictly speaking, still southerners, they had now accustomed themselves to being cool-weather people. Except for the occasional visit back 'home,' where they complained bitterly of the heat, most were destined never to return to live there again.

In projecting the eye of their imagination on this new place, the rhythm of their existence took on a pattern of its own that went from day to day and seemed to have no grander design than a desire to be carried by the positive persistence of their lives. Hammering away without a plan to work from, my family beat out a life that they hoped would show them a sign, like the hallelujah chorus that a preacher got during Sunday morning church service from the old ladies sitting in the front row pews who moaned and hummed along with him as he preached. And nothing was better for the congregation than when that preacher, in heated deliverance, would hit upon a chord in his sermon that resonated just right with these good ladies, who would throw up white-gloved hands of affirmation and nod their heads vigorously, punctuating their pleasure with a crisp "Yes, Lord!" and "Amen!" giving the preacher the sign that he was on the right track and should keep on traveling down that road.

And so this was the challenge for my young pioneer family: to find the call and response in their own lives that might ring back to them like the familiar refrain of the old spiritual "Shake-a-Hand." It's a song I remember my father playing almost every morning, just after his return from Korea. And it's precisely because he played it so often that I still find bits and pieces of the chorus floating around in my head, keeping me mindful of that time. I hear him singing along with the scratchy black disc, his rich tenor voice belting out melodic thunder-rolls: *shake-a-hand, shake-a-hand*! His voice and the music bounced off the walls of our military-issue housing, shaping our lives to its chant. The chorus extolled, in demanding exaltation, all the virtues of welcome and all the attributes of endurance that this new land would extract. It threw down the gauntlet; it taunted and dared these newcomers: *shake-a-hand, shake-a-hand, shake-a-hand, shake-a-hand, shake-a-hand, shake-a-hand, shake a hand if you can*!

Acts of Everyday

In claiming their part of this place, my family transferred their skills as southern fieldworkers to the shipyards and factories of a growing economy, wartime and then post-wartime. The strength of their bodies was their best and only bankable asset. They would sink this sweat investment into

becoming employees who provided the services where strong backs and hands were required. Among these people were my father and many of his friends who were returning home from Korea, coming back to their waiting families. They found jobs in rotating shifts at places like Seattle's military hospitals, where, as nurses' aides, they lifted bodies and changed bedpans while waiting to land a more substantial government service job.

In this new employment with the Seattle Engineering Department's street maintenance crew, my father exchanged the lifting of human bodies for the moving of earth, which he did, literally, by digging ditches, planting trees, and cleaning streets. For the times, these were good jobs that allowed young families to move out of the city's temporary military-housing projects of Rainier Vista and High Point into new homes.

The destination for most of these young families would be Seattle's central city. There, this postwar influx of Negroes would give rise to one of the city's first waves of 'white flight' to the suburbs. Some families, in their escape, flew away so quickly that it seemed they barely took time to gather up all of their belongings. In the house our family chose, we found the closets still filled with the former family's forgotten or overlooked possessions. Christmas and party decorations were left on shelf tops. Spools of thread, pieces of brocade fabric, and other small treasures always seemed to be turning up. My favorite finds were new, fresh-out-of-the-store rolls of crepe paper. These seemed like such a luxury that I don't think we ever used them. I couldn't imagine how anyone could have left them behind.

These old homes on small city plots were now our own quadrants on the earth. And for my family and the other young families who joined us, it was a threshold we had finally passed over, our wedge against time, our anchor of permanence, something to pass on.

Necessary to all of this were our mothers, who worked in the dress and beauty shops of a then-small city, who were also doing 'day work' on the side, which was the cleaning of other people's homes. This 'day work' took us out of our small enclave in the center of the city and connected us to the lives of the well-to-do in neighborhoods beyond our borders, homes and lives we slipped in and out of in the evenings or on the weekends. These were the families we came to know mostly by the clutter that needed cleaning, by the dirt in the kitchens, bedrooms, and living rooms, and at the bottom of swimming pools. Our mothers cleaned their houses and cared for their kids. And these children, seemingly otherwise unattended, could on first encounter seem a little strange to our eyes.

There was the family my mother worked for on Mercer Island in 1958 whose two young daughters could be found, on occasion, sitting on top of the refrigerator when we arrived. From this odd perch, they would rake baby rattles feverishly across their teeth to "relieve anxiety," as my mother was told by their mother. And, "the girls are only eating hot dogs these days," the parents would say, telling us not to worry, that it was just a passing phase. Strangely enough, this rattle-rubbing, hot-dog-eating behavior usually lasted only for the time it took these parents to leave the house, in addition to the two seconds it took my mother to whisk the girls down from the refrigerator. She would then prepare regular food, which, miraculously, the girls seemed to be able to eat with no problem.

Unfailingly, the children in these houses would have names like Cindy, Saucy, and Susie. To my ears these were pert, buoyant sounds that floated light and airy above the ground, ringing in the breeze like wind chimes, whereas the names that filled the rooms of my house—Eula Mae, Annie Bea, and Ethel Lee—brought to mind the feeling of something heavy, full bodied, and dense, the weight of butter pound cake.

The families whose houses we cleaned were not bad people, but neither did they appear especially happy or more interesting because they could afford to have their homes cleaned. They did, however, seem to have aspirations and possibilities somewhere under all of their possessions which intimated that their lives were separated from ours by more than just the space in time it took for us to arrive.

I tried to imagine them killing chickens in their basements, as was done in the homes of many of my relatives. But since there were no basements in these ranch-style ramblers, where would they put the chopping block that held the razor-sharp ax that lay in wait to lop off the chicken's head after its neck was wrung? For that matter, where would they put the chickens? Or the freshly skinned rabbits that could always be found hanging from the top of garage doors at my mother's cousin's house, looking like they had just stepped out of their winter coats, or the hogs-head cheese being made in vats in the kitchen, or the fried brains and eggs for breakfast? And what about the cow tongues on the drain board, always terrifying at eye level, and their share of the slaughtered pig? Pig's-feet, pig's-tail, pig's-ears. There was lots of lard in our lives. I never saw lard at these houses, nor old rags, dried stiff, hanging over drain pipes under the sink. Everything seemed to have its own place behind doors, even the mops, rags, and yard tools.

My forebears were not heroic, nor did they seek to conquer nature or anything else. My

people would never be found jumping from airplanes, nor skiing down or hiking up mountains. They were a one-foot-in-front-of-the-other kind of people, who climbed each day like it was a mountain on which they were grinding out a temporary place just to hang on, and this was adventure enough. They were a never-miss-a-day-of-work-unless-you-were-dead kind of people, a habit carried here from the field and the farm. These behaviors, ones which could easily be mistaken for such virtues as a good work ethic or loyalty, were actually a manifestation of their insecurity, of their fear that in the space of even the briefest absence they could be forgotten and thus lose their place.

In truth, my people weren't sure what it took to root a person to a place, let alone how anyone came to be remembered. So much had been lost along the way that by now there remained few keepsakes in our lives and even fewer records, save an old, deteriorating family Bible that contained the names of my mother's family on her father's side. Maybe it was because our lives in this place were so new, or because we lived with the dead so vividly alive in our imaginations, that we did not reminisce. My family rarely took pictures or noted birthdays. There was something ephemeral, even existential in how we lived, as if we could avoid, by not taking pictures, that inevitable point in the future when someone would look at the photos and not know who we were.

So when my family chose to weave our lives into this new land, our comfort was settled into small wooden rowboats, usually rented, coming with the sole accessory of a makeshift concrete anchor, cast in the mold of a discarded coffee can.

New Land, Old Visions

Many of my relatives were unaccustomed to seeing water in every direction. In this new land, their desires did not draw them toward the relatively open waters of Puget Sound. These they would leave to those with the big boats and mastheads, the fishing fleets you could see in the waters separating Ballard from the rest of Seattle. My family would instead be content to take up with the landlocked freshwater bodies of the lakes, or to cast out their lines into the frigid salt waters of Puget Sound from some stationary spot on the shore. It would be hard to imagine these

transplanted southerners, even in their deepest love of fishing, wanting to take on the sea. In our lives there was no definition for the sea. We did not imagine its leading to someplace wonderful. We did not desire to enter its vastness. It was too biblical, too full of omens.

Magic, superstition, and religion shaped us. We believed in what we could not see, in the mystery of invisible forces that could come and snatch us up at any moment, without warning. In my world there was never any shortage of people who were willing to outline for me, point by point, life's risks and its temporal nature. Both of my grandmothers were especially good at this. These stalwart southern immigrants, who lived with us or who were never far away, tended to have special connections to and knowledge of both heaven and hell. I imagined that this was because they were closer to death's door—which for them was really just a passageway through which they would be traveling to the everlasting light. These old women could tell you, quicker than you could correct yourself, just exactly what God and the Devil thought about bad children with devilish ways. And nothing was worse or more terrifying for me, in those days, than to be identified as a child full of the Devil, and to have one of these women, who had the gift of sight, look right into my heart, right past my intentions—which they, by the way, knew far better than I—to see into my future, and foretell that my life, by the virtue of my mischief, was going to be bleak, dark, and full of fire and suffering because I had chosen the Devil's work over God's good will.

My paternal grandmother, Mama Phevie, was more religiously possessed than most. She kept a framed portrait of Jesus hanging prominently among our family photos displayed on her living room wall. She lived no day where she did not relate to her life and death as if they were the same thing. Every event in her life, no matter how small, was underscored by a narrative of God's promise and the evils of life's temptations. Whether she was leaving the house to go downtown, or just getting up from her chair to go to the bathroom, she would raise her hand in solemn personal testimony, saying, "I'll be back, God willing," in this way letting you know that she was fully aware that your time and hers could come at any moment, and that all had best be ready when the Lord called.

Our lives, like the conditions of our arrival in the Northwest, were governed by a combination of chance and divine intervention. There was the salt thrown over our shoulders to keep people from telling lies on us, or the gripping of some metal object to prevent bad luck in the

case that one of us had to have some piece of clothing sewn up while we were wearing it, or the complete silence that was required in the face of thunder and lightning, lest we risk having God rain hell down upon our heads.

Thunder and lightning were forces especially to be revered, "not to be messed with," as my mother would say. She believed that storms were one of the ways the Almighty had to keep us mindful of His presence, and it was an offense not to pay attention. In our family it was the women who seemed to be in charge of the messages and admonitions coming from the firmament. Whether this was true or not, I can't say, but I don't recall my father, or any of the men in my life, offering opinions on the spiritual significance of lightning, the meaning of a sudden wind, or the portent of flickering lights. Their realm seemed to be the earth, and if the weather spoke to them at all, it was about where to fish or what to plant.

On the occasion of the rare Northwest thunder and lightning storm, televisions, telephones, and almost anything electric had to be disengaged from or turned off immediately. While my mother saw the need and use for electricity, she distrusted electricians, believing, I think, that they were in cahoots with the Devil by messing round with God's power. As children, we were not allowed even to be in the room during electrical repairs, for fear that the electrical currents might somehow get loosed from the opened sockets into the room. In my mother's mind, electricity was directly related to lightning, which was related to God. Therefore, televisions and telephones were not only temptations that could unwisely divert our human attention away from God's business, but worse, they could act as deadly conduits through which lightning could travel to work its mysterious wrath in divine ordinance. You could be burned to a cinder right on the spot.

When a storm struck, she would gather us up, my father included, and herd us toward their bedroom to wait it out. While we all lay there on their double bed, mostly in silence, drifting off into storm-fraught dreams, my mother might tell us, in low whispers, true stories from her Louisiana childhood. These stories were full of spirits floating on dark back roads, appearing to the faithless travelers who failed to heed a warning, who would have to learn the hard way the foolishness of defying nature and not being respectful of God's power.

Horizon Sleepers (1976)
Colored pencil on paper
$25\frac{3}{4}'' \times 22''$
Collection of the artist

Winter Fishing

In winter our world contracted into cold, short days circled in dim light, into a season when fishing the lakes in boats was, for a time, off limits. In striking out, we were among the tribes of fishermen who could be seen around the city walking along lake shores in search of places from which to perch and cast out lines. We moved in wandering caravans of families: hunched over, overcoated, boot-slogging mothers, fathers, kids, and grandparents spilling out of Seattle's central city.

In those days winter fishing might take us up beyond the city line as far north as Bothell. The fishing there was from an old abandoned logging mill, where train trestles stretched out over the northernmost tip of Lake Washington. Parking our car up on the road, we would hike down one of the small trails bordering the tracks until we reached the spot where the rails took us like a precarious skybridge, right out over the water. Moving carefully, with the poles and our own packed food in hand, we took pains to keep our balance, feeling danger always close at hand, knowing that with one missed step we could find ourselves falling many feet into the icy water below, or that one of us could as easily fall through one of the countless openings on the elevated track. The thought of straddling one of those railroad ties that threatened to inflict some painful new split into the body was enough to keep fear and attentiveness ever present.

For me, this was our perch and bullhead spot. Mostly it was bullheads. These were ugly, inedible little fish that must have been starving in the winter—it was the only explanation I could fathom for why we caught so many. That my parents threw them back almost faster than they caught them proved to be of little discouragement to these homely fish, which kept right on biting. It was as if they knew they were unwanted, so they would bite when nothing else would, just to aggravate us.

As late as the early 1960s there were still paths situated between large, sprawling houses on Magnolia Bluff which were used by public nomads like us, leading down between the trees to the shoreline or out onto cliffs of the bluff, close enough to cast out a line. We tromped over evergreen undergrowth, the pungent aroma of fir and pine oils wafting into the nostrils, opening the pores. It sharpened the breath on each inhalation as the damp, cold air cut small pathways into the chest.

As we trod past the homes in these neighborhoods, I tried to imagine what we looked like

to the people in these houses, moving, as we did, like silent shadow families, carrying bundles in oily brown paper sacks, buckets, and bamboo fishing poles. Maybe in our soundless movement we didn't look like anything to them at all. Maybe we were no more noticed than the wind in the trees, pushing through. Maybe they could no more imagine our lives than we could imagine theirs. Sometimes I would see a curtain move, or glimpse a head in silhouette in a window, nothing more.

On winter days, perched above Puget Sound, I can smell the salt in the air. It sticks to my skin like sweat. The ground, like the air, is heavy with dampness, seeping out moisture that soaks up through my clothing, chilling skin and bones until my body is so numb that it moves like cold rubber.

Moving along the path, the sodden earth gives way under my feet. My eyes glimpse the cliff's edge. I have inherited my father's fear of heights and, for an instant, I am transfixed. I don't know if it's the edge that fascinates me, or the mystery held in the distance between the edge and the watery drop below. All I know is that I feel an urge to jump. In the space of one step, I imagine myself falling, air leaving my body as my stomach lurches upward into my throat. It's a curious sensation of lusty fear. It's an excitement, the thought of which makes me queasy. Heart pounding, I continue to walk along with my family, in silence.

The place we find is a circular, grassy promontory facing west. Planting ourselves, poles unfurl. Each one of us takes up position on the ground where the earth, molding itself to our bottoms, will hold us. And there we will sit, waiting through long, uninterrupted spells broken only by a request to pass the bait, or a comment on what looks like a bite.

There is something about these old people in my family that allows them to sit for long periods in Buddha-like positions, breathing silently into the overcast fog, fingers molded close around a pole, waiting for a fish to bite. To wait well is to survive the space inhabited by hope, desire, fear, dread, and want, like waiting for a lover to return from the sea, or for something good to happen in your life. Theirs is a quiet, enduring reserve, one not to be explained, but lived. One that bares at its center a secret that is earned through long hours of practice, forged by concentration and will—like the forces of persistence that bring them here.

This is my instruction in patience. Under gray skies, gulls fly overhead, swooping down, gliding on invisible currents, calling in high-pitched, plaintive cries, hypnotizing us in their floating dives, melding into the grayness the way one day melds into another. We have no gear. Everything is makeshift. Food is simple communion. Adult hands unwrap and pass sandwiches—bologna and sweetpickle relish on white bread. Taken in salt air, mixed with the soil of earthworms from the digging we've done, they taste like the mud of two countries pasted there under our fingernails.

The Paintings

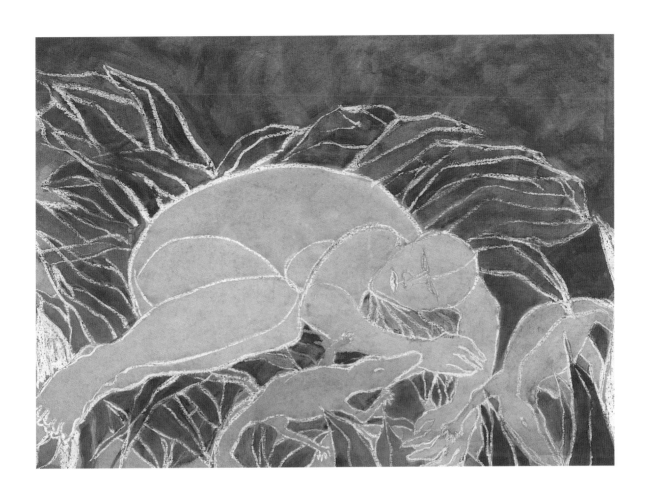

PLATE 1 / **For Women Who Sleep with Crocodiles** (1982)
Tempera on mulberry paper
25″ × 31″
Collection of King County Arts Commission, Washington

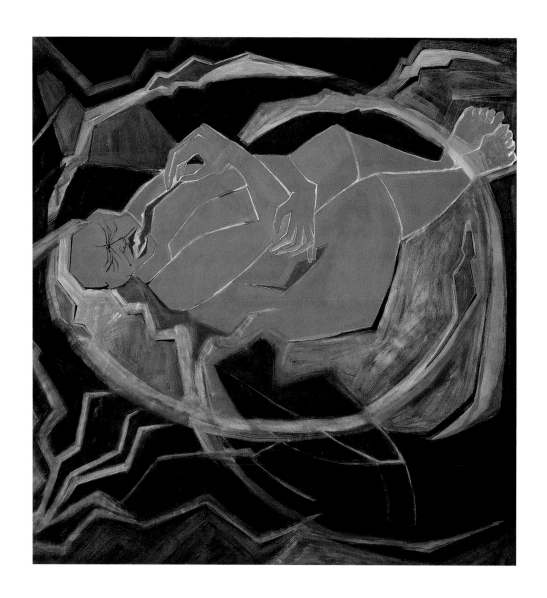

PLATE 2 / **Communion** (1983)
Tempera on mulberry paper
40″ × 38″
Collection of Rebecca Bogard

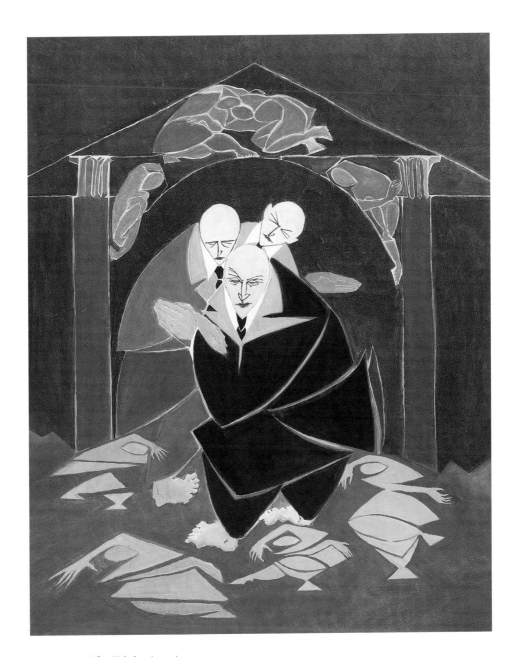

PLATE 3 / **The Trinity** (1984)
Tempera on mulberry paper
46″ × 36″
Collection of Barry Mar

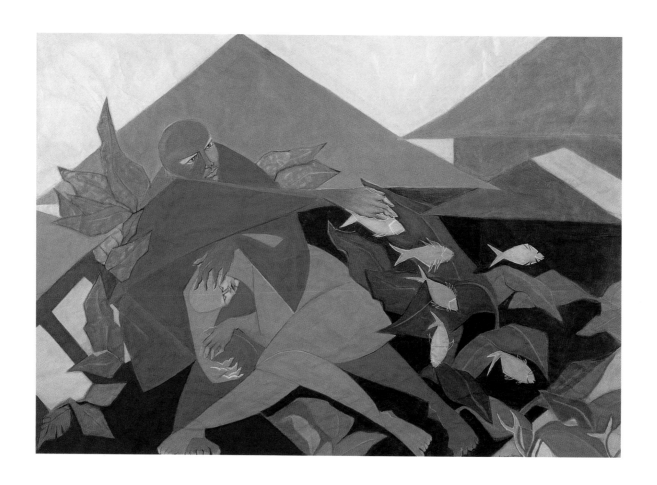

PLATE 4 / **Reunions, My Mother and Dreams of Fish** (1984)
Tempera on mulberry paper
$36\frac{1}{2}'' \times 53''$
Collection of the artist

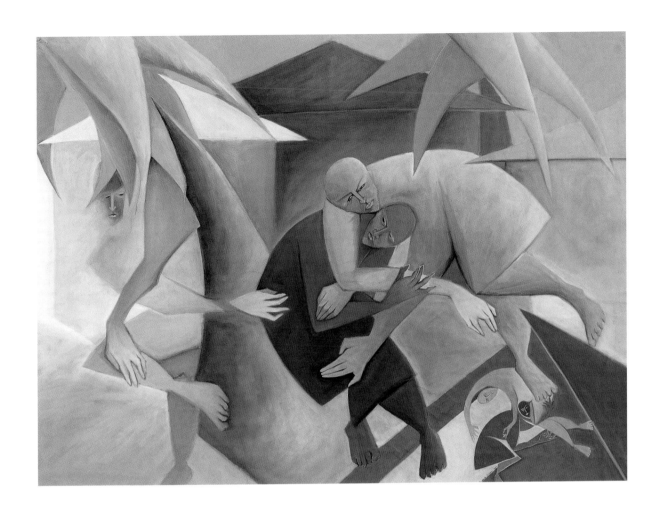

PLATE 5 / **Luna Rescue at Daybreak** (1986)

Tempera on mulberry paper

$41\frac{1}{2}'' \times 54\frac{1}{2}''$

University of Washington Medical Center, Seattle

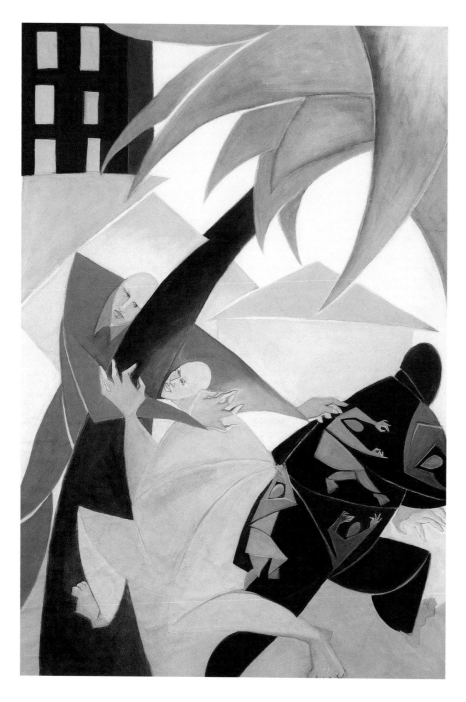

PLATE 6 / **Passing Secrets** (1985). *Tempera on mulberry paper, 56¾″ × 41½″. Collection of Dr. David and Elinor Gordy*

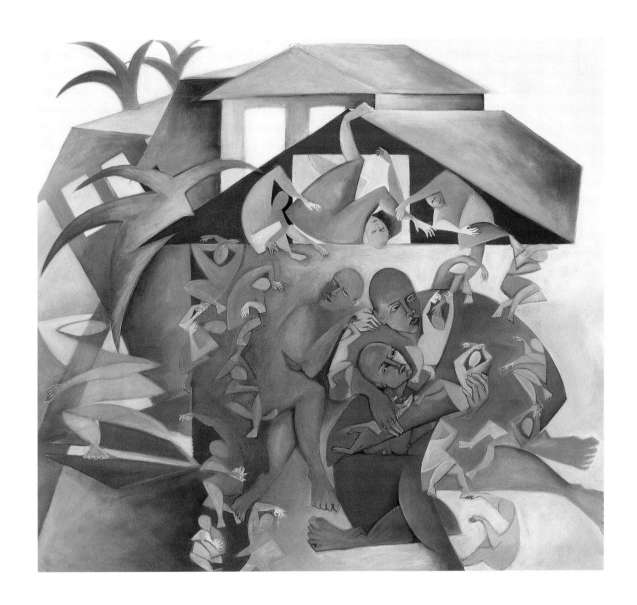

PLATE 7 / In My Father's House There Are Many Roomers
(1986)
Tempera on paper
40¾″ × 44¾″
Collection of the artist

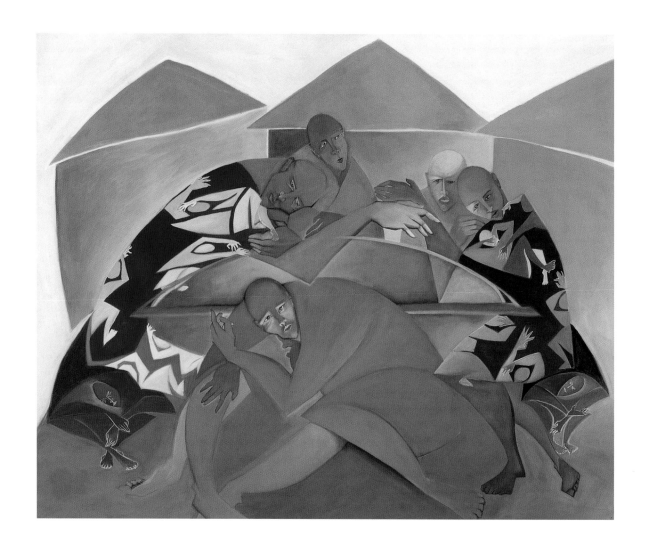

PLATE 8 / **Catechism** (1986)

Tempera on paper

$40\frac{3}{4}'' \times 49\frac{3}{4}''$

Collection of Nancy Rawles and Martine Pierre-Louie

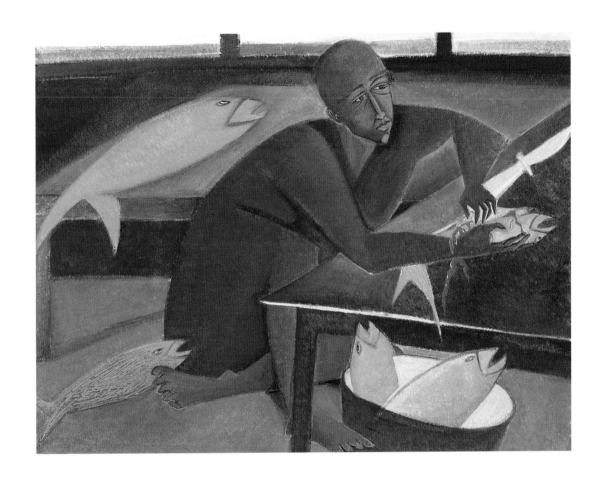

PLATE 9 / **Man Cleans Fish** (1987)

Tempera on paper

18¾″ × 22″

Collection of Deborah Atkinson

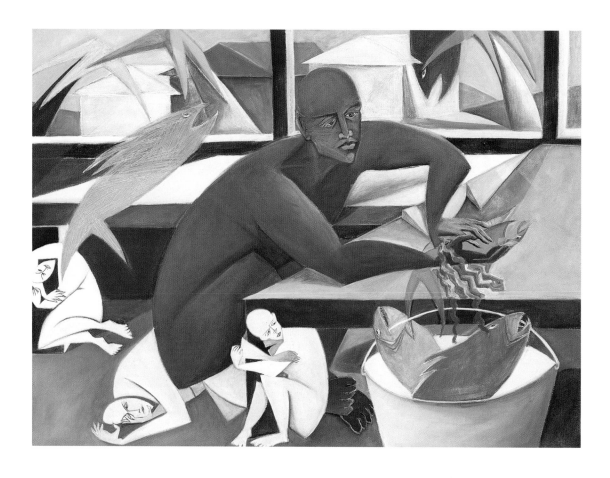

PLATE 10 / **A Man Cleaning His Fish #1** (1987)

Tempera on paper

$27^{3}/_{4}'' \times 35^{1}/_{2}''$

Collection of Jane Ellis and Jack Litewka

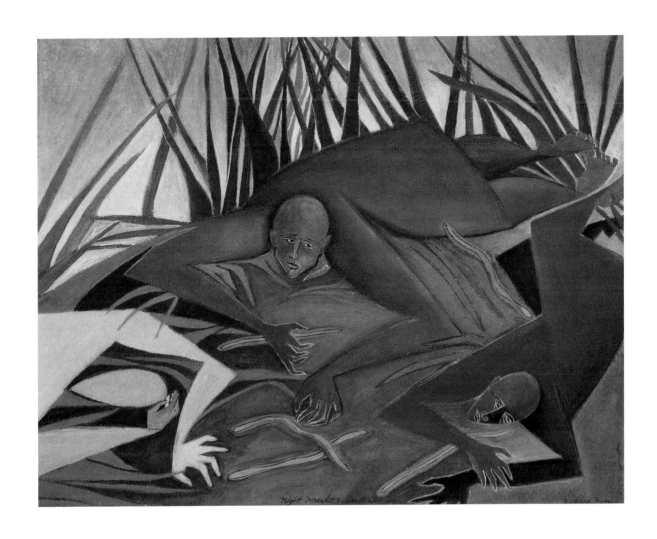

PLATE 11 / **Night Crawlers and Earth Worms** (1987)

Tempera on paper

19″ × 22″

Collection of Dr. David and Elinor Gordy

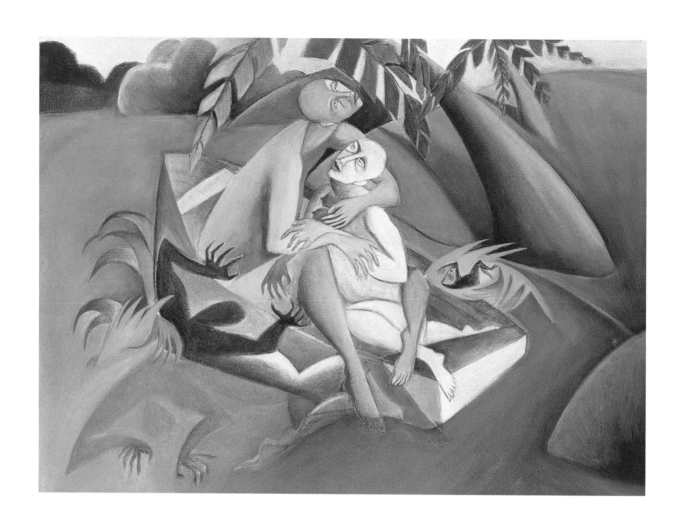

PLATE 12 / **The Boat** (1988)

Egg tempera on paper

15″ × 18″

Collection of the artist

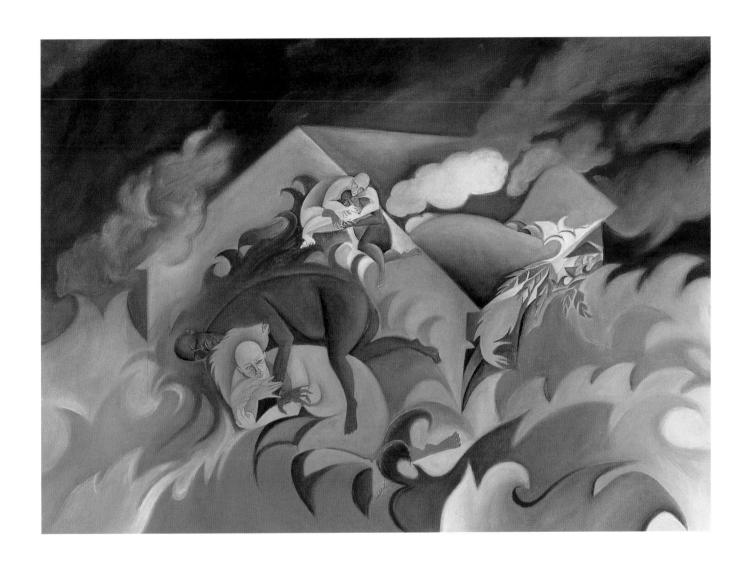

PLATE 13 / **The Storm Watch** (1988)

Egg tempera on paper

30¼" × 36"

Courtesy of Francine Seders Gallery, Seattle

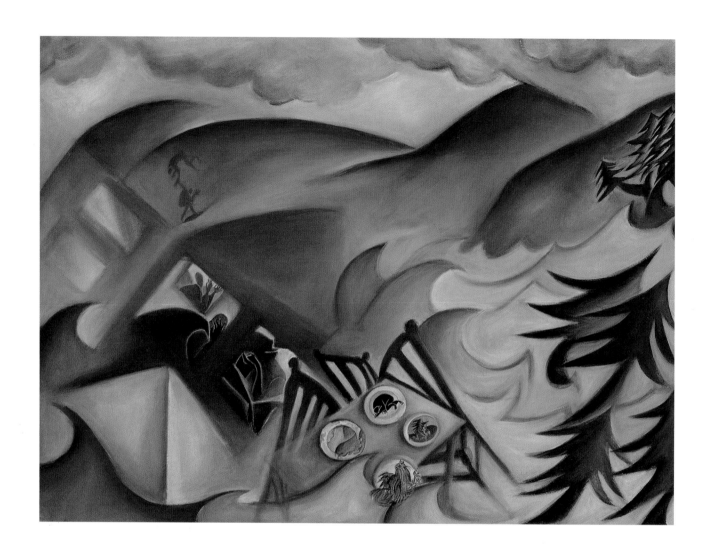

PLATE 14 / **Broken Landscape** (1990)

Egg tempera on paper

$30\frac{3}{4}'' \times 38\frac{1}{2}''$

Collection of Junior League of Seattle

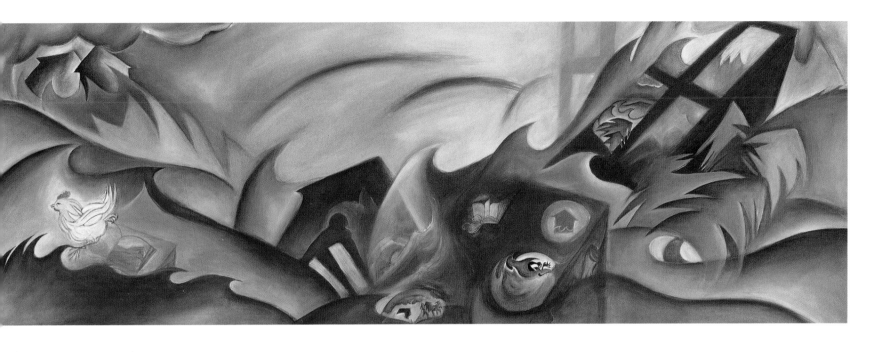

PLATE 15 / **Echo Tides** (1991)
Egg tempera on paper
$22\frac{3}{4}'' \times 49\frac{3}{4}''$
Seattle Art Museum, Northwest Acquisition Fund

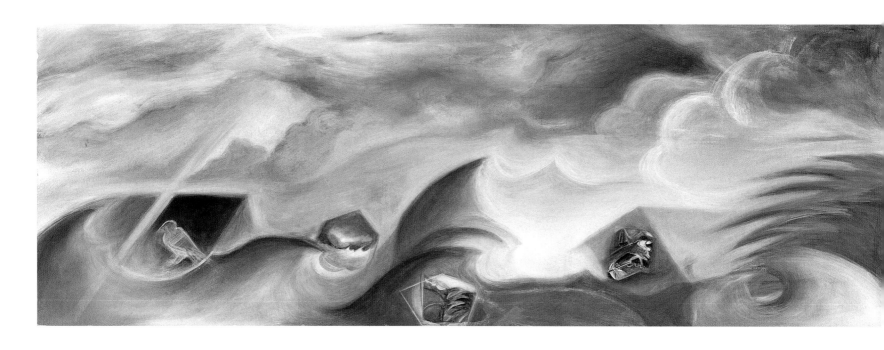

PLATE 16 / **Lost House** (1992)

Egg tempera on paper

18″ × 40″

Courtesy of Francine Seders Gallery, Seattle

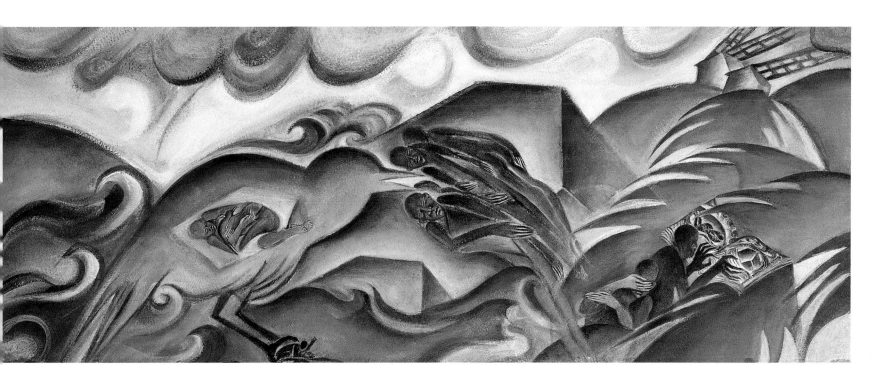

PLATE 17 / **The Book of Telling** (1995)

Egg tempera on paper

$11\frac{1}{2}'' \times 30''$

Collection of David and Charlotte Sherman

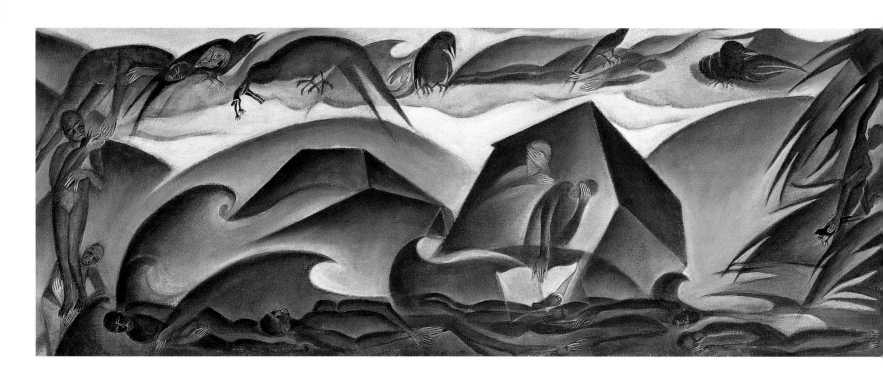

PLATE 18 / **Point Blank, Blank Book** (1995)

Egg tempera on paper

17″ × 35¾″

Collection of Tom Booster and Cynthia Hartwig

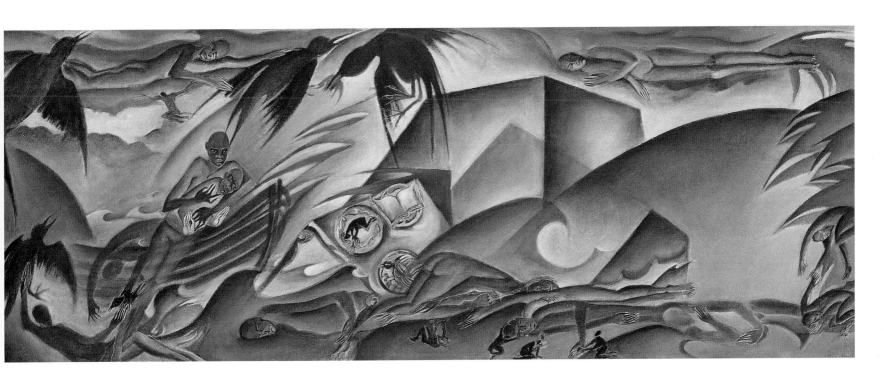

PLATE 19 / **Place Set, Lost Place** (1995)
Egg tempera on paper
$17\frac{3}{8}'' \times 35\frac{1}{2}''$
Courtesy of Francine Seders Gallery, Seattle

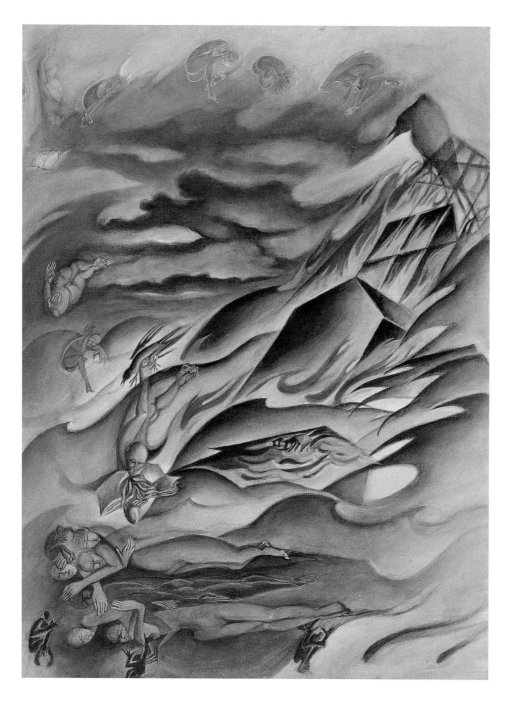

PLATE 20 / **City in Fire Light** (1997). *Egg tempera on board, 20″ × 15″. Collection of the artist*

CHRONOLOGY

BARBARA EARL THOMAS

Birthplace

1948 Born in Seattle, Washington

Education

1967 Graduated from Garfield High School, Seattle

1968 Seattle Central Community College

1973 Bachelor of Arts, University of Washington, Seattle

1976 University of Grenoble, France

1977 Master of Fine Arts, University of Washington, Seattle

Awards

1971 Links Art Award, The Seattle Chapter of the Links, Inc.

1996 The Howard S. Wright Award, Seattle Arts Commission

1997 Artist Trust Tenth Anniversary Award for Artistic Achievement and Community
 Contribution

One-person Exhibitions

1997 *Celebrating Olympic College and Lee Brock in Their Fiftieth Years: Barbara Earl
 Thomas, an Exhibition*, Olympic College Gallery, Bremerton, Washington

1995 *A Fire in the Heart*, Skagit Valley College, Mt. Vernon, Washington
 The Book of Telling, Francine Seders Gallery, Seattle

1994 *Barbara Thomas: The Fallen House*, Whatcom Museum of History and Art,
 Bellingham, Washington

1990 *Requiem for a Tilted World*, Francine Seders Gallery, Seattle
 Talking Back to the Storm: New Figurative Work by Barbara Thomas, Mitchell
 Museum, Mt. Vernon, Illinois

1989 The Art Gym, Marylhurst College, Marylhurst, Oregon

1987 The Evergreen State College, Olympia, Washington

1985 Sheehan Gallery, Whitman College, Walla Walla, Washington

1984 *Recent Work*, Francine Seders Gallery, Seattle
 Executive Office Gallery, King County Courthouse, Seattle

1983 *For Women Who Sleep with Crocodiles*, Art Center Gallery, Seattle Pacific
 University

1980 A Contemporary Theatre Gallery, Seattle
 Greenwood Galleries, Seattle (also 1977, 1979)

Selected Group Exhibitions

1997 *Civil Progress: Life in Black America*, Greg Kucera Gallery, Seattle

 Memory and Mourning: American Expressions of Grief, Washington State History
 Museum, Tacoma

1996 *Raven: Icons and Omens*, Cornish College of the Arts, Seattle

1995 *Washington: 100 Years, 100 Paintings*, Bellevue Art Museum, Washington

1993 *The Art of Microsoft*, Henry Art Gallery, University of Washington, Seattle

1992 *Documents Northwest: The Poncho Series; 1492/1992*, Seattle Art Museum

1989 *Washington to Washington: Women in Art Today*, National Museum of Women in
 the Arts, Washington, D.C. (traveling exhibition)

1987 *Northwest '87*, Seattle Art Museum

 Aesthetics of the American Northwest, Evans-Tibbs Collection, Washington, D.C.

 Masks: A Contemporary Perspective, Whatcom Museum of History and Art,
 Bellingham, Washington

1986 *Poetry in Art*, Francine Seders Gallery, Seattle

Public and Corporate Collections

City of Seattle 1% for Art Collection

Junior League of Seattle

King County Public Art Collection, Seattle

Microsoft Corporation, Redmond, Washington

Seattle Art Museum

Seafirst Bank, Seattle

University of Washington Medical Center, Seattle

WRQ, Inc., Seattle

Washington State Arts Commission, Cedar Heights Junior High School, Kent

Western Washington University, Bellingham

BIBLIOGRAPHY

Books and Catalogues

BRUCE, CHRIS. *The Art of Microsoft*. Seattle: Henry Art Gallery, 1993.

BRYANT, ELIZABETH. "Barbara Earl Thomas." In *Gumbo Ya Ya: An Anthology of Contemporary African-American Women Artists*, edited by Leslie King Hammond. New York: Midmarch Arts Press, 1995.

KUCERA, GREG, editor. *Civil Progress: Life in Black America*. Seattle: Greg Kucera Gallery, 1997.

MCLERRAN, JENNIFER. "Narrative and Figurative Trends: Telling Differences." In *Modernism and Beyond: Women Artists of the Pacific Northwest*, edited by Ruth Askey and Laura Brunsman. New York: Midmarch Arts Press, 1993.

NICHOLS, ELLEN. *Northwest Originals: Washington Women and Their Art*. Portland, Oregon: MatriMedia, 1990.

ROUNDTREE, MELISSA. *Talking Back to the Storm: New Figurative Work by Barbara Thomas.* Mt. Vernon, Illinois: Mitchell Museum, 1990.

SIMS, PATTERSON. *Documents Northwest: The Poncho Series, 1492/1992.* Vol. 10, no. 2. Seattle: Seattle Art Museum, 1992.

THOMAS, BARBARA. "On Life and Art: An Odyssey." In *Florilegia: A Retrospective of Calyx, a Journal of Art and Literature by Women, 1976–1986,* Calyx editorial collective. Portland, Oregon: Calyx Books, 1987.

———. "Gwendolyn Knight Lawrence." *WCA Honor Awards,* National Women's Caucus for Art, 1993.

———. "A Parent Variation." In *A Single Mother's Companion,* edited by Marsha Leslie. Seattle: Seal Press, 1994.

———. "Generations." In *A Matter of Colors.* Seattle: Pacific Arts Center, 1995.

———. "Intersections." In *Civil Progress: Life in Black America,* edited by Greg Kucera. Seattle: Greg Kucera Gallery, 1997.

———. "Sweet Hope Waiting." In *Between Species,* edited by Linda Hogan, Deanna Metzer, and Brenda Peterson. New York: Ballantine Books, 1998.

Periodicals

AMENT, DELORES TARZAN. "Gallery Celebrates Black History Month." *Seattle Times,* February 14, 1988.

ASKEY, RUTH. "Barbara E. Thomas." *Artweek,* September 27, 1990.

BASA, LYNN. "Three Artists Mix Poetry with Their Painted Artwork." *Journal-American* (Bellevue, Washington), June 22, 1986.

BRUNSMAN, LAURA. "Distinct Voices." *Reflex,* March/April 1988.

BRYANT, ELIZABETH. "Precision Thrives Beneath the Chaos in Thomas Paintings." *Seattle Post-Intelligencer,* September 20, 1990.

CARLSSON, JAE. "Barbara E. Thomas at Francine Seders Gallery." *Reflex,* November/ December 1990.

CONNELL, JOAN. "Exhibit Lets Figures Tell Stories." *Bellingham Herald,* February 2, 1986.

GLOWEN, RON. "Indecisive Paintings." *Artweek*, May 17, 1980.

———. "Explorations: Documents Northwest, 1492/1992." *Artweek*, December 17, 1992.

HACKETT, REGINA. "Exhibit Hangs the Good and Bad Side-by-Side." *Seattle Post-Intelligencer*, November 29, 1989.

———. "Individualists' Styles Share the Spotlight in Show of Women Artists." *Seattle Post-Intelligencer*, January 1993.

———. "A NW Tribute: The Art of Microsoft." *Seattle Post-Intelligencer*, July 1, 1993.

———. "Artists Explore Seattle-Africa Ties." *Seattle Post-Intelligencer*, February 28, 1994.

———. "Putting Their Art Where Their Hearts Are." *Seattle Post-Intelligencer*, April 21, 1995.

———. "Painting Is Positive Energy for Late-Bloomer Thomas." *Seattle Post-Intelligencer*, October 17, 1995.

HARRIS, JOANNE. "Portfolio." *American Visions*, August/September 1996.

LANCASTER, MICHAEL. "Working for Art." *Walla Walla Union Bulletin*, February 21, 1985.

MATHIESON, KAREN. "Thomas Underlines Work with Disastrous Mischief." *Seattle Times*, September 22, 1990.

MITCHELL, LEATHA S. "Before/During/After the Flood/Middle Passage/Conflagration." *International Review of African American Art* 14, no. 2, 1997.

SMALLWOOD, LYN. "The Many Colors of Black Artists." *Seattle Weekly*, March 2, 1988.

THOMAS, BARBARA. "An Artist Speaks: Reporting from Inside the Body." *Artist Trust Newsletter*, Winter 1988.

———. "In Public: The Politics of Exclusion." *Reflex*, March/April 1989.

———. "An Artist's Portfolio." *Utne Reader Online Edition*, July 1995.

———. "Some Fly." *Raven Chronicles*, Fall 1996.

———. "Art and Other Futures." *Aorta: Art and Culture Magazine*, November/December 1996.

TREMBLAY, GAIL. "Prayers for Being Human." *Reflex*, December/January 1995/96.

TSUTAKAWA, MAYUMI. "Barbara Thomas and Heather Dew Oaksen." *Artist Trust*, Fall 1994.

ACKNOWLEDGMENTS

THANK YOU TO THE COLLEAGUES, FRIENDS, AND RELATIVES OF THE artist who spoke with me at length: Johnnie Butler, Christine Lamb, Gwendolyn Knight Lawrence, Jacob Lawrence, Heather Oaksen, Diane Shamish, Rick Simonson, and Michael Spafford. Thank you to Francine Seders and her gallery staff for photographic archives and general helpfulness, and to the collectors who opened their homes and offices to me; their names appear beside the reproductions of their treasured paintings. Thank you to my critical readers: Chiyo Ishikawa, Suzanne Kotz, and Gretchen Van Meter. And thank you to Barbara Thomas for submitting to the many pains and instigating the many pleasures of creating this book.

—*Vicki Halper*

SPECIAL THANKS TO KIT MAAS, WHOSE EDITING SKILLS AND FRIENDship are priceless; to Nancy Rawles and Ursula Hegi for reading my work and pushing me toward the sound of my own voice; and to Heather Oaksen and Lauri Conner, also faithful readers. To Director Pat Soden and the University of Washington Press for giving me this opportunity, and to Gretchen Van Meter, editor, and Audrey Meyer, art director, who have, with great care, shaped every detail. To Vicki Halper for her artful sorting and assembling of the facts and themes of my life and art. To Francine Seders and the gallery staff for their research and support of my work.

And of course to my husband, Rick Simonson, who makes most things in my life possible, and to his parents, Dick and Jan, whose love and encouragement are unequivocal. To Walter and Maggie Carr for including me in the Elliott Bay Book Company family; and to the memory of Denise Levertov for the gift of her thoughtful observations about my work. And thanks as well for the loving support of my sister Lyndia, who traveled through darkness across a great distance to be here to complete our family and to help me remember our shared past. And to her daughter Michelle and granddaughter Baileh, who will be the keepers of the stories.

And, most of all, thanks to Jacob and Gwen Lawrence, whose love, generosity, and friendship never cease to humble and amaze me. May I be guided always by their example.

—*Barbara Earl Thomas*